Tarsila do Amaral
The Moon

BEVERLY ADAMS

THE MUSEUM OF MODERN ART, NEW YORK

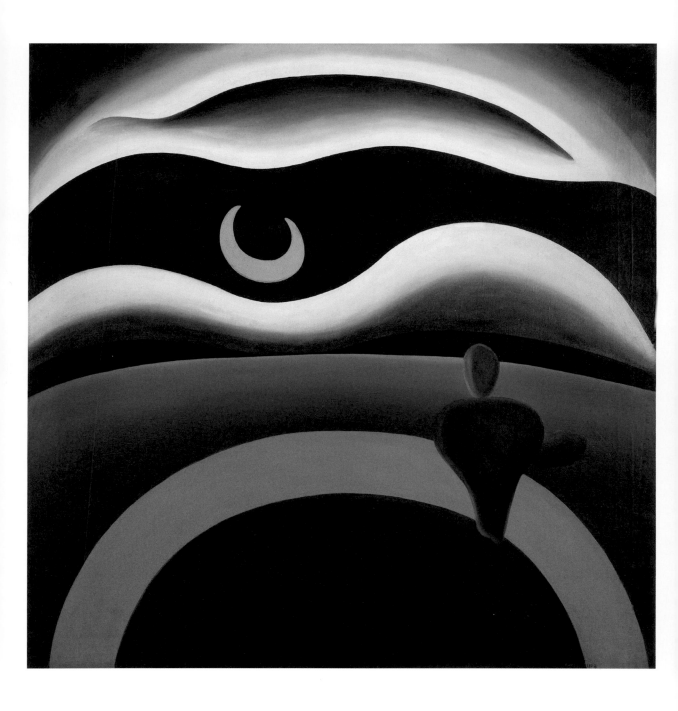

Tarsila do Amaral (Brazilian, 1886–1973). *The Moon*. 1928. Oil on canvas, 43⁵⁄₁₆ × 43⁵⁄₁₆" (110 × 110 cm).

TARSILA DO AMARAL'S PAINTING *THE MOON* (1928), A HIGHLY STYLIZED, DESOLATE nocturne balanced between earth and sky, looks quite modern, with its crisp lines and flat planes of saturated color, but it does not seem particularly Brazilian. In Amaral's night landscape, the earth is a stack of curved, precisely painted areas of color. A semicircle of green is topped by a curved blue band, representing a river, which is followed by another swath of green that expands to the midpoint of the painting. A bright-yellow crescent moon rides low on the horizon, mimicking the shape of the blue arc of water in reverse. While the earth is an orderly progression of green and blue, the sky undulates with layers of blacks, blues, and whites, shaped, presumably, by moonlight. Rooted at the inside edge of the river on the right is a slightly humanoid prickly pear cactus, the only indicator, though ambiguous, of place. As an abstraction, the landscape need not be faithful to nature or to country: this could be the moon from the artist's point of view, from her personal universe in her own inventive style. Yet Amaral's focus was on Brazil. *The Moon* represents her desire to create a new form of expression for her homeland—an effort that would inspire Anthropophagy, Brazil's most important cultural movement of the early twentieth century, and make Amaral the country's most celebrated modern painter.

The Moon was the largest of twelve paintings Amaral exhibited at Galerie Percier in Paris in June 1928, in the second and final of her solo shows in that city. The works, all painted in Brazil in 1927–28, included many uncanny landscapes animated by strange creatures or plants, as well as two figure paintings: a double portrait of the artist's stepson and his grandfather surrounded by exuberant vegetation, and *Abaporu*, a curious desert scene that would later become emblematic of her work [**FIG. 1**].

Several months earlier, in January 1928, Amaral had given *Abaporu* to her husband, Oswald de Andrade, as a birthday present. The work, then recently completed, features an enormous orangish figure sitting on a small slice of dark-green ground next to a saguaro cactus, from which grows a brilliant yellow flower that doubles as the sun. *Abaporu* most likely preceded *The Moon*, and, as in that painting and other works in her 1928 show, the landscape is reduced to an arc of earth, the sky, and a single plant. Both the cactus and the giant that dominate the scene are smooth and tubular. The figure has one enormous arm and an even larger bent leg planted firmly on the green hill, while its tiny head rests above a small arm at the top of the picture. European and Brazilian sources suggest themselves: The figure's pose, ironically, recalls Rodin's famous sculpture *The Thinker* (1880–81), while its huge foot echoes the singular appendage in *Person Throwing a Stone at a Bird*, a 1926 painting by the Spanish Surrealist

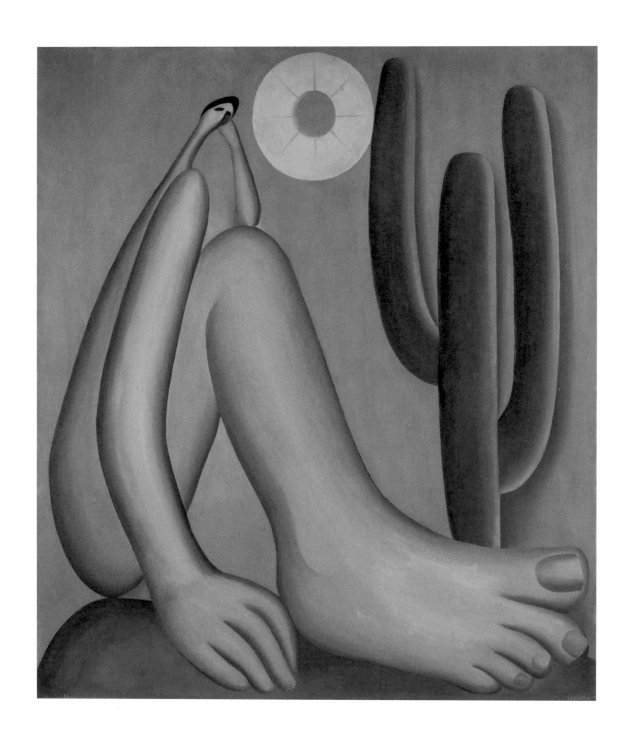

FIG. 1. Tarsila do Amaral (Brazilian, 1886–1973). *Abaporu.* 1928. Oil on canvas, 33 9/16 × 28 3/4" (85.3 × 73 cm).
COLECCIÓN MALBA, MUSEO DE ARTE LATINOAMERICANO DE BUENOS AIRES

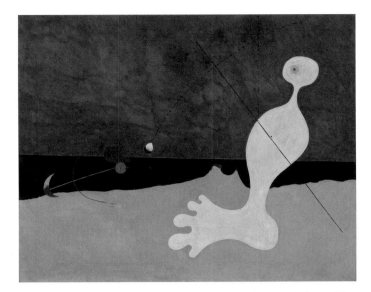
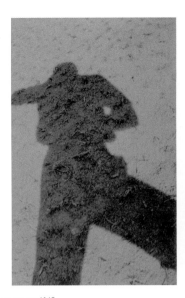

FIG. 2. Joan Miró (Spanish, 1893–1983). *Person Throwing a Stone at a Bird.* 1926. Oil on canvas, 29 × 36¼″ (73.7 × 92.1 cm). THE MUSEUM OF MODERN ART, NEW YORK. PURCHASE

FIG. 3. Mário de Andrade (Brazilian, 1893–1945). *My Shadow. St. Tereza do Alto 1-1-28.* 1928. Black-and-white photograph, 2⁷⁄₁₆ × 1⁷⁄₁₆″ (6.1 × 3.7 cm). ARQUIVO DO INSTITUTO DE ESTUDOS BRASILEIROS DA UNIVERSIDADE DE SÃO PAULO. FUNDO MÁRIO DE ANDRADE

Joan Miró **[FIG. 2]**.¹ *Abaporu* also resembles a photographic self-portrait made around the same time by Amaral's writer friend Mário de Andrade in which his shadow is distorted to similar proportions **[FIG. 3]**. The title character in Mário's novel *Macunaíma: A Hero without a Character* (written in 1926 and published in 1928) suffers a similar fate: doused with poisonous manioc juice, his body grows to be gigantic while his head stays the same size.² Regardless of its inspiration, Amaral recalled of *Abaporu* that she "wanted to make a picture that would startle Oswald. . . . Something really out of the ordinary."³

In an oft-repeated story, Oswald was immediately taken by the strange painting and called a friend, the writer Raul Bopp, to come see it right away. Together with Amaral they found a title for the painting by looking through a dictionary of Indigenous Tupi-Guarani languages first compiled by the Jesuit missionary Antonio Ruiz de Montoya in the seventeenth century: *abá* is the word for "person," and *puru* means "one who eats human flesh."⁴ Imagining the figure as a cannibal, Oswald and Bopp, inspired, began to plot. The result was an iconoclastic new vision for Brazilian culture. Drawing on the history of ritual cannibalism, once practiced in Brazil, in which victorious warring Indigenous groups ceremonially consumed their enemies in order to inherit their quali- ties, Oswald and Bopp called for a new, modern-day cultural cannibalism. They advocated neither the embrace nor the rejection of imported culture but rather

MANIFESTO ANTROPOFAGO

Só a antropofagia nos une. Socialmente. Economicamente. Philosophicamente.

Unica lei do mundo. Expressão mascarada de todos os individualismos, de todos os collectivism. De todas as religiões. De todos os tratados de paz.

Tupy, or not tupy that is the question.

Contra toda as cathecheses. E contra a mãe dos Gracchos.

Só me interessa o que não é meu. Lei do homem. Lei do antropofago.

Estamos fatigados de todos os maridos catholicos suspeitosos postos em drama. Freud acabou com o enigma mulher e com outros sustos da psychologia impressa.

O que atropelava a verdade era a roupa, o impermeavel entre o mundo interior e o mundo exterior. A reacção contra o homem vestido. O cinema americano informará.

Filhos do s o l, mãe dos viventes. Encontrados e amados ferozmente, com toda a hypocrisia da saudade, pelos immigrados, pelos traficados e pelos touristes. No paiz da cobra grande.

Foi porque nunca tivemos grammaticas, nem collecções de velhos vegetaes. E nunca soubemos o que era urbano, suburbano, fronteiriço e continental. Preguiçosos no mappa mundi do Brasil.

Uma consciencia participante, uma rythmica religiosa.

Contra todos os importadores de consciencia enlatada. A existencia palpavel da vida. E a mentalidade prelogica para o Sr. Levy Bruhl estudar.

Queremos a revolução Carahiba. Maior que a revolução Francesa. A unificação de todas as revoltas efficazes na direcção do homem. Sem nós a Europa não teria siquer a sua

pobre declaração dos direitos do homem.

A edade de ouro annunciada pela America. A edade de ouro. E todas as girls.

Filiação. O contacto com o Brasil Carahiba. **Oú Villeganhon print terre.** Montaigne. O homem natural. Rousseau. Da Revolução Francesa ao Romantismo, á Revolução Bolchevista, á Revolução surrealista e ao barbaro technizado de Keyserling. Caminhamos.

Nunca fomos cathechisados. Vivemos atravez de um direito sonambulo. Fizemos Christo nascer na Bahia. Ou em Belem do Pará.

Mas nunca admittimos o nascimento da logica entre nós.

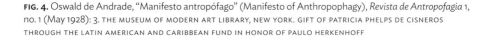

Desenho de Tarella 1928 — De um quadr. que figurará na sua proxima exposição de Junho na galeria Percier, em Paris.

Contra o Padre Vieira. Autor do nosso primeiro emprestimo, para ganhar commissão. O rei analphabeto dissera-lhe: ponha isso no papel mas sem muita labia. Fez-se o emprestimo. Gravou-se o assucar brasileiro. Vieira deixou o dinheiro em Portugal e nos trouxe a labia.

O espirito recusa-se a conceber o espirito sem corpo. O antropomorfismo. Necessidade da vaccina antropofagica. Para o equilibrio contra as religiões de meridiano. E as inquisições exteriores.

Só podemos attender ao mundo orecular.

Tinhamos a justiça codificação da vingança A sciencia codificação da Magia. Antropofagia. A transformação permanente do Tabú em totem.

Contra o mundo reversivel e as idéas objectivadas. Cadaverizadas. O stop do pensamento que é dynamico. O individuo victima do systema. Fonte das injustiças classicas. Das injustiças romanticas. E o esquecimento das conquistas interiores.

Roteiros. Roteiros. Roteiros. Roteiros. Roteiros. Roteiros. Roteiros.

O instincto Carahiba.

Morte e vida das hypotheses. Da equação **eu** parte do **Kosmos** ao axioma **Kosmos** parte do **eu.** Subsistencia. Conhecimento. Antropofagia.

Contra as elites vegetaes. Em communicação com o sólo.

Nunca fomos cathechisados. Fizemos foi Carnaval. O indio vestido de senador do Imperio. Fingindo de Pitt. Ou figurando nas operas de Alencar cheio de bons sentimentos portuguezes.

Já tinhamos o communismo. Já tinhamos a lingua surrealista. A edade de ouro.
Catiti Catiti
Imara Notiá
Notiá Imara
Ipejú

A magia e a vida. Tinhamos a relação e a distribuição dos bens physicos, dos bens moraes, dos bens dignarios. E sabiamos transpor o mysterio e a morte com o auxilio de algumas formas grammaticaes.

Perguntei a um homem o que era o Direito. Elle me respondeu que era a garantia do exercicio da possibilidade. Esse homem chamava-se Galli Mathias. Comi-o

Só não ha determinismo - onde ha misterio. Mas que temos nós com isso?

Continua na Pagina 7

FIG. 4. Oswald de Andrade, "Manifesto antropófago" (Manifesto of Anthropophagy), *Revista de Antropofagia* 1, no. 1 (May 1928): 3. THE MUSEUM OF MODERN ART LIBRARY, NEW YORK. GIFT OF PATRICIA PHELPS DE CISNEROS THROUGH THE LATIN AMERICAN AND CARIBBEAN FUND IN HONOR OF PAULO HERKENHOFF

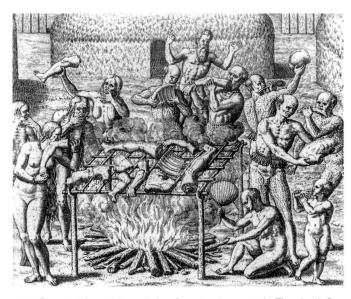

FIG. 5. Engraving depicting cannibalism from *America*, part 3, by Theodor de Bry (Frankfurt, 1592). The illustration accompanies an account by the Frenchman Jean de Léry of his experiences among the Tupinambá, an Indigenous group in Brazil, in the mid-sixteenth century.

its symbolic and critical devouring: what Oswald termed the "absorption of the sacred enemy."[5] Aspects of European culture considered useful by Brazilian artists would be retained, reimagined, and metabolically transformed, and what was not useful would be discarded, ignored, or overturned.

In May 1928 Oswald's "Manifesto antropófago" (Manifesto of Anthropophagy, or Cannibalist Manifesto) was published in the first issue of *Revista de Antropofagia*, a new journal for the budding Anthropophagic movement, edited by Bopp and Antônio de Alcântara Machado. It was illustrated by a line drawing of *Abaporu*, captioned with an announcement of Amaral's upcoming exhibition **[FIG. 4]**. The text began grandiosely, like other early modern manifestos: "Only anthropophagy unites us. Socially. Economically. Philosophically." Oswald then playfully cannibalized one of the most famous lines in European literature: "Tupi, or not tupi, that is the question."[6] Through parody, appropriation, and a dense weave of references to Brazilian and European history, he aggressively inverted the centuries-old power relations between the so-called Old and New Worlds, elevating the Indigenous past of Brazil over its colonial inheritance. For Oswald, time began not with the birth of Christ but with an act of cannibalism—the "swallowing," by the Caeté people, of the first Portuguese bishop sent to Brazil.[7] He upended the distinctions between savagery and civilization used to sustain colonialism and embraced the negative stereotypes that painted Brazil, in contrast to the supposed normality and rationality of Europe, as an irrational and barbarian hinterland **[FIG. 5]**.[8] In Oswald's reversal, Brazil, not

Europe, was the originator of ideas. "We already had Communism. We already had the Surrealist language. The golden age," he wrote. "Before the Portuguese discovered Brazil, Brazil had discovered happiness."[9]

Anthropophagy was short-lived as a movement, but its impact on Brazilian art and culture was immense, and its audacity and creative anticolonial stance inspired future generations. With *The Moon, Abaporu,* and other paintings of the late 1920s, Amaral successfully metabolized aspects of modern European art and put them to use in her larger project: the creation of an authentically Brazilian form of modern art. But it had taken her nearly a decade to arrive at this important breakthrough in her practice.

———

Like other aspiring artists from all over Europe and the Americas, Amaral went to Paris for its cultural infrastructure—its art schools, galleries, critics, and community. Born in 1886 into a wealthy coffee-growing family in the state of São Paulo, Amaral had a privileged upbringing. She began her art career in earnest in her late twenties, separating from a family-arranged marriage in 1913 and moving to the city of São Paulo, where she studied with the academic painter Pedro Alexandrino.[10] With his encouragement she went to Paris in 1920 to attend the Académie Julian, a private school for painting and sculpture frequented by women and foreigners denied access to official French schools. Writing home to her friend and fellow artist Anita Malfatti, Amaral described the range of art she encountered in Paris: "Almost everything tends towards Cubism or Futurism. . . . Many Impressionist landscapes, others are Dadaist in style."[11] Malfatti, who studied painting in Germany and the United States, had shocked the city of São Paulo with her boldly colored Expressionist portraits in a 1916 exhibition, introducing radical painting to a conservative Brazilian public [FIG. 6]. Amaral's early work in Paris was much more conventional than her friend's. *Portrait of a Woman,* for example, features a naturalistic, powdery white figure in a mauve shawl with her head downcast in partial shadow and her eyes closed [FIG. 7]. Her brown and blue hair, loosely swept back and decorated with a large pink flower, mimics the light-green swirls of the patterned backdrop. The brushwork is visible and delicate, constructing mottled areas of color. This painting was chosen to be in the 135th Salon of the Société des Artistes Français. Amaral would later ironically call it "Passport," as it was the work that won her entry into the halls of official French art.[12]

Amaral was disappointed by her lack of advancement during this first foray to Paris. "After a two-year stay in Europe," she recalled, "I returned [to Brazil] with a paint box full of beautiful colors, many beautiful dresses, and little artistic information."[13] In June 1922 Malfatti introduced her to writers and artists devoted to renewing art in Brazil. Their aim was to break away from the nineteenth-century French cultural remnants, like Realism and Symbolism, that were advocated by

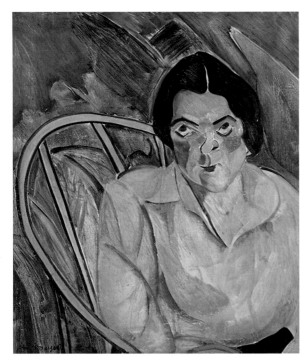

FIG. 6. Anita Malfatti (Brazilian, 1889–1964). *Silly Woman*. 1915–16. Oil on canvas, 24 × 19¹⁵⁄₁₆″ (61 × 50.6 cm). MUSEU DE ARTE CONTEMPORÂNEA DA UNIVERSIDADE DE SÃO PAULO

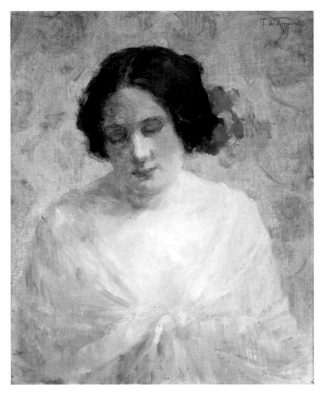

FIG. 7. Tarsila do Amaral (Brazilian, 1886–1973). *Portrait of a Woman*. 1922. Oil on canvas, 24 × 19¹¹⁄₁₆″ (61 × 50 cm). PRIVATE COLLECTION, SÃO PAULO

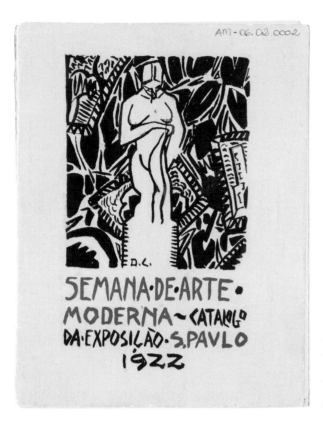

FIG. 8. Exhibition catalogue for the Semana de Arte Moderna, São Paulo, 1922, with cover design by Emiliano Di Cavalcanti. ARQUIVO DO INSTITUTO DE ESTUDOS BRASILEIROS DA UNIVERSIDADE DE SÃO PAULO. ARQUIVO ANITA MALFATTI

the National School of Fine Arts in the country's then capital, Rio de Janeiro. While European artists had shifted to experiment with new forms, art in former colonies, like Brazil, had not moved past the previous century. In February 1922 a group of artists and writers including Malfatti had organized the Semana de Arte Moderna, a weeklong celebration of modern art in São Paulo. In that year of the hundredth anniversary of Brazilian independence, the artists and intellectuals of the rapidly modernizing city positioned themselves as the national voice of modernity, framing Rio de Janeiro and its art school as out of date. They did not share a unified style or approach, but they agreed on the need for a "Brazilianization" of the nation's cultural production. The watershed event featured exciting new poetry, music, and a fine arts exhibition. The composer Heitor Villa-Lobos, famous for his reconsideration of Brazilian folk music in his classical compositions, performed every day. Malfatti exhibited, as did the painter Emiliano Di Cavalcanti, who designed the event's catalogue [**FIG. 8**]. Amaral was in Paris at the time, but upon her return to São Paulo she quickly joined Malfatti, Oswald, Mário de Andrade, and the writer Paulo Menotti del Picchia to form a coalition of like-minded progressive artists, the Group of Five [**FIG. 9**].

FIG. 9. Anita Malfatti (Brazilian, 1889–1964). *Group of Five*. 1922 Ink and colored pencil on paper, 10 ⁷⁄₁₆ × 14 ³⁄₈″
(26.5 × 36.5 cm). From left: Tarsila do Amaral, Paulo Menotti del Picchia, Oswald de Andrade, Mário de
Andrade, and Anita Malfatti. COLEÇÃO DE ARTES VISUAIS DO INSTITUTO DE ESTUDOS BRASILEIROS DA UNIVERSIDADE
DE SÃO PAULO. COLEÇÃO MÁRIO DE ANDRADE

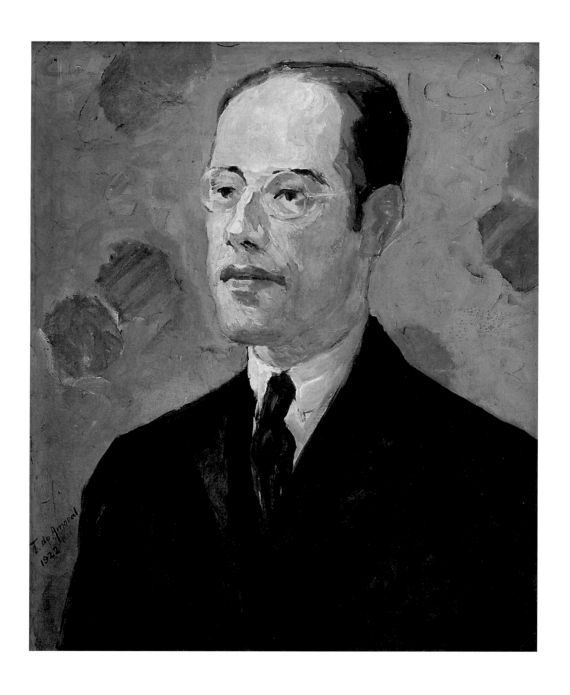

FIG. 10. Tarsila do Amaral (Brazilian, 1886–1973). *Portrait of Mário de Andrade.* 1922. Oil on canvas, 21¹⁄₁₆ × 18⁵⁄₁₆″ (53.5 × 46.5 cm). ACERVO ARTÍSTICO-CULTURAL DOS PALÁCIOS DO GOVERNO DO ESTADO DE SÃO PAULO

FIG. 11. From left: Oswald de Andrade, Tarsila do Amaral, Yvette Farkou, Fernand Léger, Constantin Brâncuși, and Maximilien Gauthier at the Foire du Trône, Paris, July 1926

"It sounds mendacious . . . but it was in Brazil that I first came into contact with modern art," Amaral wrote. "Encouraged by my friends, I enthusiastically painted some pictures that reflected a delighted use of violent color."[14] One of these was a portrait of her new friend Mário [**FIG. 10**], whose readings from his recently published book of poems, *Hallucinated City* (1922), caused a sensation at the Semana de Arte Moderna. Invigorated by the call for the modern in São Paulo, or, as she would later recall, "contaminated by revolutionary ideas," in late 1922 Amaral returned to Europe, where she was joined by Oswald in January 1923.[15]

That year would be transformative for both the artist and her collaborator and future husband. Amaral and Oswald immersed themselves in every aspect of Parisian modernism, from fashion to theater, poetry to visual art. In May 1923 they met the Swiss poet Blaise Cendrars, who became a close friend and a guide through Parisian avant-garde circles. He connected the couple with his friends, including the artists Constantin Brâncuși, Albert Gleizes, and Fernand Léger, the poet Jean Cocteau, the composer Erik Satie, and the powerful modern art dealer Ambroise Vollard [**FIG. 11**]. Amaral purchased modern European art for herself and brought Brazilian collectors to artists' studios and galleries. Her own studio in Montmartre, rumored to have once been that of Paul Cézanne, became a meeting place for European modernists and Brazilians abroad. Abandoning the Académie Julian, she studied briefly with André Lhote, Gleizes (whom she called the "Cubist pontiff"), and Léger.[16]

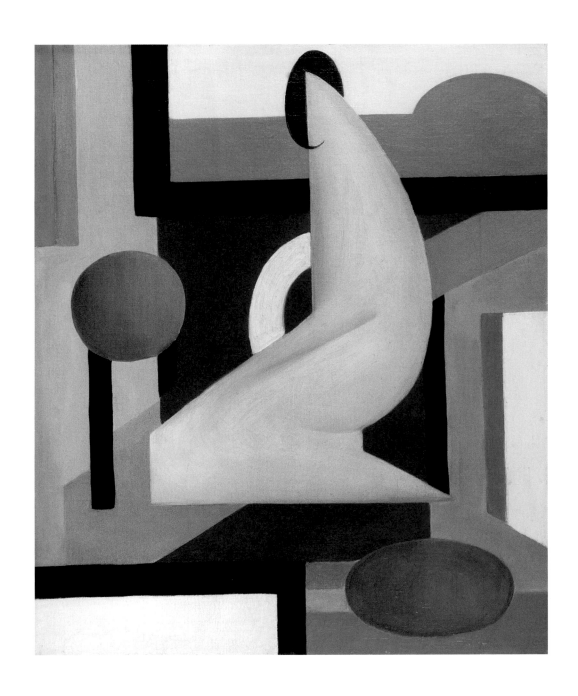

FIG. 12. Tarsila do Amaral (Brazilian, 1886–1973). *The Model.* 1923. Oil on canvas, 21 ¹¹⁄₁₆ × 18 ⅛″ (55 × 46 cm).
COLLECTION HECILDA AND SÉRGIO FADEL, RIO DE JANEIRO

The Model, painted in 1923, demonstrates Amaral's break with her academic training, its graphic flatness and geometrized figure departing dramatically from her portraits of the previous year [FIG. 12]. Yet the artist considered it another "academic" exercise—this time from the academy of Cubism. She famously declared that Cubism, a style that revolutionized painting in Paris in the early part of the twentieth century, was an "artist's military service. In order to be strong, every artist must be conscripted."[17] But Amaral was never, in terms of style, a Cubist painter. Instead, learning Cubism's basic principles was for her a means of cutting ties with the past. It was also a tool to facilitate the future of her own style and vision: "My spirit did not rest even after I had finally identified with Cubism. I began to want to create a more personal art and, thus, perfect the methods I had learned, accommodating them my way and in keeping with my temperament."[18] This approach was an early, if rather gentle, version of the consumption and absorption of the desired traits of the sacred enemy later advocated in Anthropophagy.

Young Brazilian artists and intellectuals at home, mostly from the elite classes, were delving into folk art, popular Afro-Brazilian music, and Indigenous traditions in search of motifs and subject matter that could inspire a specifically Brazilian strain of modern art.[19] Brazilian artists in Paris were similarly engaged, like Di Cavalcanti (in the city from 1923 to 1925), who painted many samba scenes and images of the so-called popular classes [FIG. 13].[20] In her quest for a more "personal" art, Amaral began to explore Brazilian subjects, painting Rio de Janeiro's iconic bay and a work titled *Country Girl* [FIG. 14]. The figure in the latter kneels in the same pose as the subject of *The Model*, though facing the opposite direction; her skin is darker, perhaps in recognition of the racial diversity of Brazil. Instead of a hard-edged backdrop, she is set in a somewhat more dimensional landscape of grass, trees, and low, beige buildings reduced to basic forms. In her blue and black hand she holds a curious green leaf, which is shaped like a doll with a full skirt and two slender arms. Both figure and leaf/doll tower over a structure that might be a dollhouse or another building. Amaral referred to this painting in a letter to her parents in April 1923, declaring a new ambition:

> I want to be the painter of my country. How grateful I am for having spent my whole childhood on the farm. My memories of those times are becoming precious for me. I want, in art, to be the *caipirinha* [country girl] from São Bernardo, playing with straw dolls, like in the most recent picture I am working on.[21]

The adoption of a *caipira* identity might have been counter to her privileged upbringing in the rural aristocracy (Oswald described Amaral in a poem as a "*caipirinha* dressed in Poiret"[22]), but for the artist her memories of life in the countryside were raw materials to be mined in service of a distinctly Brazilian identity for her art.[23]

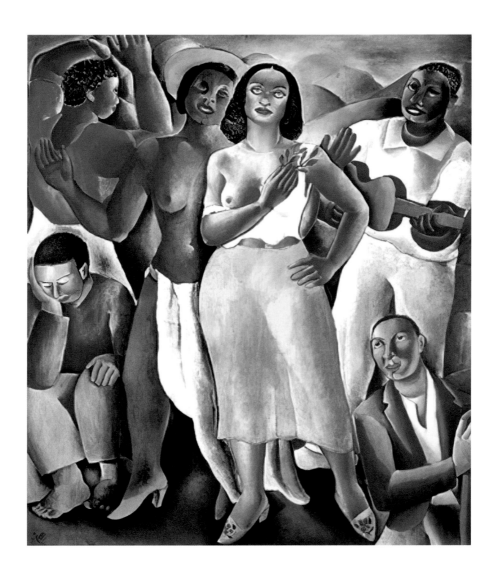

FIG. 13. Emiliano Di Cavalcanti (Brazilian, 1897–1976). *Samba.* 1920s. Oil on canvas, 69¹¹⁄₁₆ × 60⅝″ (177 × 154 cm). FORMERLY COLLECTION JEAN AND GENEVIEVE BOGHICI, RIO DE JANEIRO (NOW LOST)

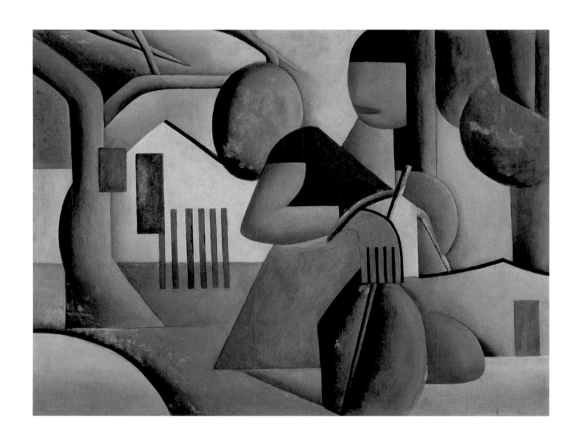

FIG. 14. Tarsila do Amaral (Brazilian, 1886–1973). *Country Girl*. 1923. Oil on canvas, 23 ⅝ × 31 ⅞″ (60 × 81 cm).

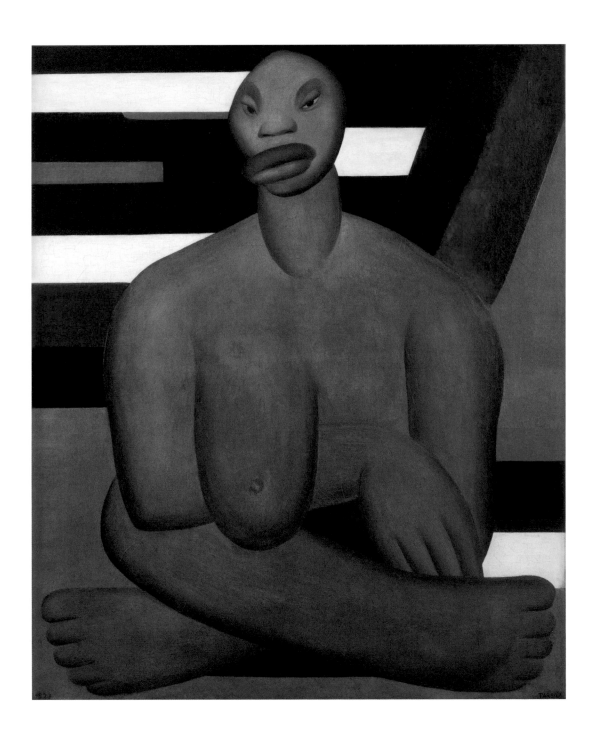

FIG. 15. Tarsila do Amaral (Brazilian, 1886–1973). *The Negress.* 1923. Oil on canvas, 39 ⅜ × 32″ (100 × 81.3 cm).
MUSEU DE ARTE CONTEMPORÂNEA DA UNIVERSIDADE DE SÃO PAULO

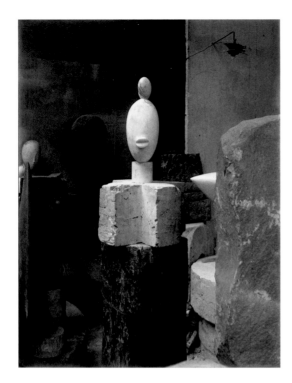

FIG. 16. *White Negress [I]* in Constantin Brâncuși's studio, Paris, c. 1923

This strategy is evident in another work from that year. In *The Negress*, a solid, cross-legged, ocher-colored figure with her right arm under one elongated breast sits in front of an abstract background of horizontal stripes, with a two-tone green palm frond emerging from behind her left shoulder **[FIG. 15]**.[24] Amaral was born two years before the abolition of slavery in Brazil, and as a child she interacted with coffee-plantation workers who had been formerly enslaved by her family. She explained that this image emerged from a story of enslaved women who stretched their breasts so that they might more easily feed their children while picking crops.[25] Though deliberately Brazilian in its subject matter, *The Negress* may also have been a response to the artist's more immediate surroundings. Paris in the 1920s was characterized by a frenzy of interest in African culture and artifacts, and in its exoticized, distorted, and essentially racist portrayal of a Black woman, the painting is not unlike works produced and avidly consumed by Amaral's European friends.[26] The woman's masklike face, hairless head, and exaggerated lips, for example, have been compared to Brâncuși's marble sculpture *White Negress [I]*, also made in Paris in 1923 **[FIG. 16]**.[27] Cendrars and Léger collaborated on the primitivist ballet *The Creation of the World*, based on African mythology, which premiered in Paris the same year. Cendrars wrote the libretto, which was related to his 1921 book *Anthologie nègre (The African Saga)*, and Léger designed the set and the elaborate costumes,

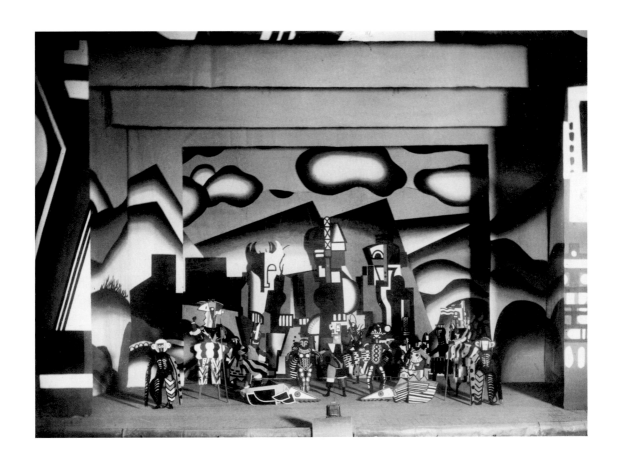

FIG. 17. A scene from *The Creation of the World* at the Théâtre des Champs-Elysées, Paris, 1923, with Fernand Léger's set design and costumes

borrowing directly from African art he had seen in Paris exhibitions [**FIG. 17**]. With *The Negress,* Amaral introduced Brazilian content into her work while also satisfying the prevailing taste for the "exotic" and the "primitive," an attempt, perhaps, to both represent Brazil and harness the appeal of her national origin in Paris.[28]

Mário, poking fun at the Parisian art world's love of "isms" and its fascination with all things African, wrote to Amaral in November 1923 and urged her to bring her talents home and put them in service to Brazil:

> Tarsila, Tarsila, return back into yourself. Abandon [Juan] Gris and Lhote, impresarios of decrepit criticism and decadent aesthesias! Abandon Paris! Tarsila! Tarsila! Come to the virgin forest, where there is no black art, where there are no gentle streams either. There is VIRGIN FOREST. I have created virgin-forestism. I am a virgin-forester. That is what the world, art, Brazil, and my dearest Tarsila need.[29]

Although she did not entirely abandon Paris, she did heed his call. When she returned home a month later, she declared to the press: "I am profoundly Brazilian and will study the taste and art of our *caipiras.* . . . I hope to learn from those who have not yet been corrupted by the academies."[30] She began her exploration in April 1924, on a twenty-one-day trip through Brazil with Oswald, Mário, Cendrars, and the collector Olívia Guedes Penteado. The group traveled first to Rio de Janeiro for Carnival and then through the state of Minas Gerais, an experience that strengthened Amaral's dedication to representing Brazil in her work and prompted a shift in focus from figure studies to landscapes. She produced pared-down, elegant line drawings, some of which would illustrate Cendrars's book of poetry about the journey, *Feuilles de route* (Road Maps), published later that year [**FIG. 18**]. Her drawings would also figure in Oswald's 1925 poetry collection *Pau-Brasil* (Brazilwood), named after the first Brazilian export commodity, and she designed the book's cover, a stylized Brazilian flag [**FIG. 19**].[31]

Amaral's first solo exhibition, mounted at Galerie Percier in June 1926, featured paintings mostly made in the previous two years, now known as her Pau-Brasil period [**FIG. 20**]. A month before their group trip in 1924, Oswald had published a manifesto with that name in a Rio de Janeiro newspaper. "Manifesto da poesia pau brasil" (Pau-Brasil Poetry Manifesto) described the culture of Brazil in a telegraphic style, arguing that Brazilian poetry, if "true to one's region and time," could be part of the larger movements of modern literature, "exported" to the world to counter the mere adoption of imported literature. The tract celebrated the contradictions of Brazil: "We have a dual heritage—the jungle and the school. Our credulous mestizo race, then geometry, algebra and chemistry after the baby's bottle and herbal tea. 'Go to sleep my baby or the bogeyman will get you,' mixed with equations."[32] It also called for the use of "native authenticity" and "inventiveness and surprise" in Brazilian art—tools

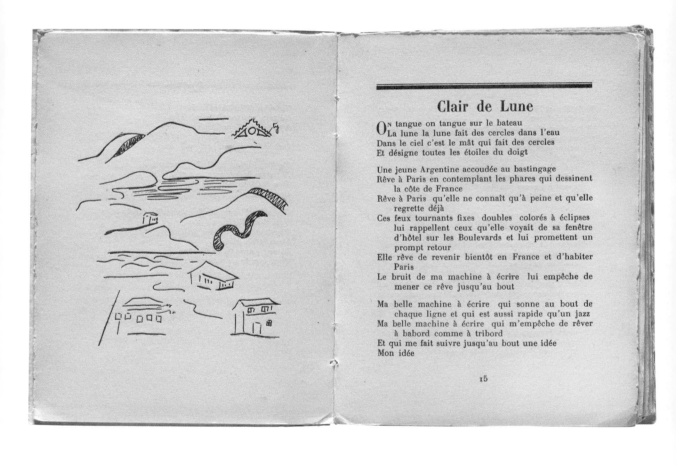

Clair de Lune

On tangue on tangue sur le bateau
La lune la lune fait des cercles dans l'eau
Dans le ciel c'est le mât qui fait des cercles
Et désigne toutes les étoiles du doigt

Une jeune Argentine accoudée au bastingage
Rêve à Paris en contemplant les phares qui dessinent
la côte de France
Rêve à Paris qu'elle ne connaît qu'à peine et qu'elle
regrette déjà
Ces feux tournants fixes doubles colorés à éclipses
lui rappellent ceux qu'elle voyait de sa fenêtre
d'hôtel sur les Boulevards et lui promettent un
prompt retour
Elle rêve de revenir bientôt en France et d'habiter
Paris
Le bruit de ma machine à écrire lui empêche de
mener ce rêve jusqu'au bout

Ma belle machine à écrire qui sonne au bout de
chaque ligne et qui est aussi rapide qu'un jazz
Ma belle machine à écrire qui m'empêche de rêver
à babord comme à tribord
Et qui me fait suivre jusqu'au bout une idée
Mon idée

15

FIG. 18. Spread from *Feuilles de route* (Road Maps), by Blaise Cendrars (Paris: Au Sans Pareil, 1924), with illustration by Tarsila do Amaral. THE MUSEUM OF MODERN ART LIBRARY, NEW YORK

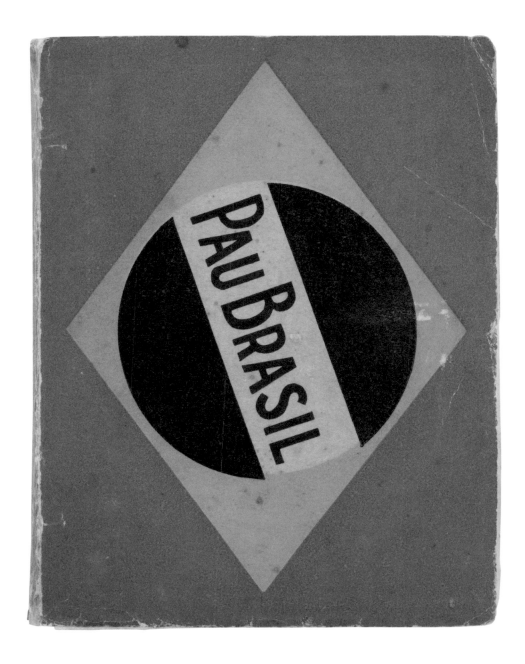

FIG. 19. Cover of *Pau-Brasil* (Brazilwood), by Oswald de Andrade (Paris: Au Sans Pareil, 1925), designed by Tarsila do Amaral. BIBLIOTECA DO INSTITUTO DE ESTUDOS BRASILEIROS DA UNIVERSIDADE DE SÃO PAULO. COLEÇÃO MÁRIO DE ANDRADE

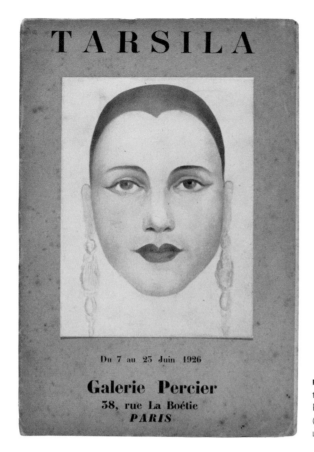

to "redress the balance of academic influence."[33] The landscapes in Amaral's 1926 exhibition featured local content rendered in a modern style that joyously centered the Brazilian vernacular. In flat, stacked compositions featuring Afro-Brazilians and rural scenes juxtaposed with modern cityscapes, she embraced pastel pinks and light greens, *caipira* colors associated with the popular culture she had encountered in her childhood and during her recent travels. The streamlined cityscapes are filled with signs of technological progress. *Central Railway of Brazil (E.F.C.B.)* features the train station that linked the states of São Paulo, Rio de Janeiro, and Minas Gerais [**FIG. 21**]. The painting is dominated by boldly outlined electrical poles, bridges, and tracks, with a hilly background upon which sits a cluster of modest houses and the village church—colonial heritage and rapid modernization existing simultaneously. A similar clump of dwellings fills the upper register of *Hills of the Favela* [**FIGS. 22, 23**]. Favelas, impoverished urban and suburban encampments that grew with the abolition of slavery and increasing rural-to-urban migration, first appeared in Rio de Janeiro at the turn of the twentieth century. The hillside scene, populated by six

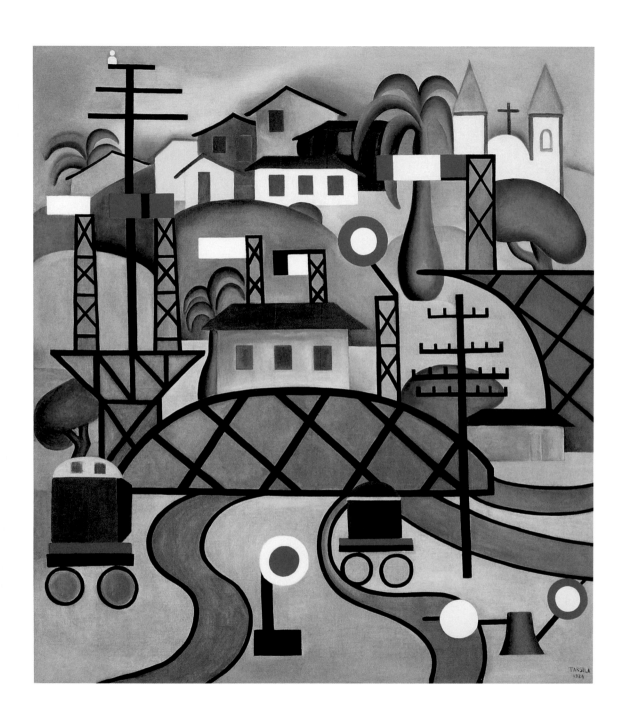

FIG. 21. Tarsila do Amaral (Brazilian, 1886–1973). *Central Railway of Brazil (E.F.C.B).* 1924. Oil on canvas, 55¹⁵⁄₁₆ × 50″ (142 × 127 cm). MUSEU DE ARTE CONTEMPORÂNEA DA UNIVERSIDADE DE SÃO PAULO

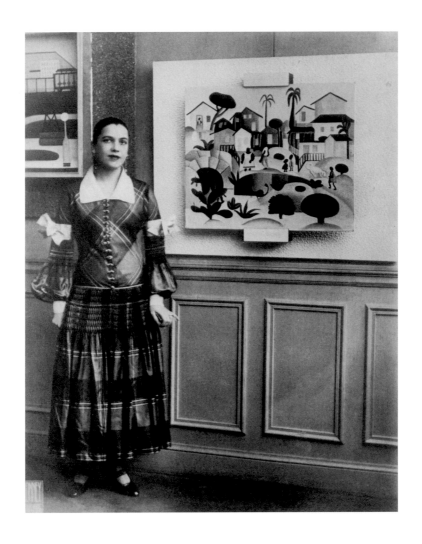

FIG. 22. Tarsila do Amaral with *Hills of the Favela* (1924), Galerie Percier, 1926

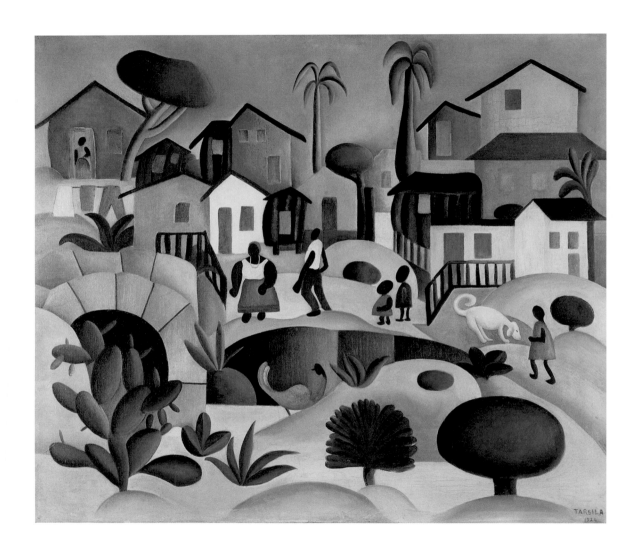

FIG. 23. Tarsila do Amaral (Brazilian, 1886–1973). *Hills of the Favela.* 1924. Oil on canvas, 25 ⅜ × 29 ¹⁵⁄₁₆″ (64.5 × 76 cm).
COLLECTION HECILDA AND SÉRGIO FADEL, RIO DE JANEIRO

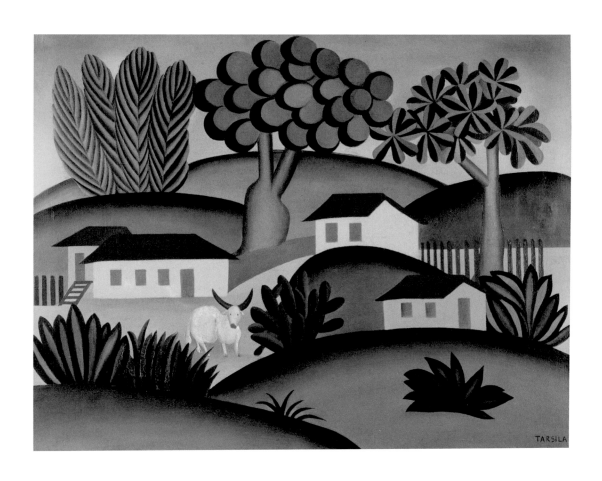

FIG. 24. Tarsila do Amaral (Brazilian, 1886–1973). *Landscape with Bull I.* c. 1925. Oil on canvas, 19 11/16 × 25 5/8″ (50 × 65 cm). COLLECTION ROBERTO MARINHO/INSTITUTO CASA ROBERTO MARINHO, RIO DE JANEIRO

Afro-Brazilian residents, two animals, palm trees, and a large cactus, recalls the opening lines of Oswald's Pau-Brasil manifesto: "Poetry exists in facts. The shacks of saffron and ocher among the greens of the hillside favelas, under cabraline blue, are aesthetic facts."[34]

Likely because of its representation of Afro-Brazilians, *Hills of the Favela* had secured Amaral's exhibition at Galerie Percier. It was Cendrars who introduced her to André Level, the gallery's director and a collector of African art.[35] Still traveling in Brazil, Cendrars contributed a poem from *Feuilles de route* to the exhibition catalogue. Parisian critics, when not focusing on the elaborate Art Deco frames by the designer Pierre Legrain, the artist's connection to Cendrars, or her stylistic links to Léger, stressed the perceived naivete of the work: "The art is so simple that some might be described as stencils on exotic themes of charming invention."[36] According to *Vogue, Landscape with Bull I*, a verdant scene of rolling hills and stylized trees and cacti [FIG. 24], was rendered "with a freshness of expression and an almost childlike sensibility that recall the manner of the celebrated Douanier Rousseau."[37] Amaral had admired the work of the self-taught painter Henri Rousseau in Pablo Picasso's studio, yet a naive artist she was not. She had deliberately absorbed the lessons of academic painting and then Cubism and reinvented them in candy-colored *caipira* forms to craft her own synthetic style. In fact, as Amaral unlearned her academic training and placed Brazilian culture at the center of her practice, her methods were not dissimilar to those of her French contemporaries who looked to the "primitive" to rejuvenate their painting. But this was overshadowed in Paris by her work's otherness—its palm trees, zebu bulls, and favelas—and Amaral's identity as a Brazilian. Parisians could not see beyond the "exotic themes of charming invention."

Not all the works in her 1926 show featured cityscapes, rural communities, or recognizably Brazilian landscapes. Amaral had begun experimenting with a new direction as early as 1924. *The Cuca*, painted in Paris, depicts a frog, a giant caterpillar, and a mysterious creature with a birdlike tail [FIG. 25]. They face a golden cuca, a Brazilian bogeyman of legend rumored to kidnap or swallow disobedient children who will not go to bed on time, as mentioned by Oswald in his Pau-Brasil manifesto. The curious cartoonish creatures are set in a landscape of fanciful plants, including a central purple tree with fanning heart-shaped leaves. The green of the landscape circles irregular pink, blue, and mauve stripes, which fill the center of the painting. The cuca, with one foot on a leaf, hovers above these patches of color, which cannot quite be understood as land or water. The painting's embrace of enigmatic imagery and the dreamlike manner in which it is depicted would be the focus of the artist's next body of work—*The Moon* and her other Anthropophagic paintings.

———

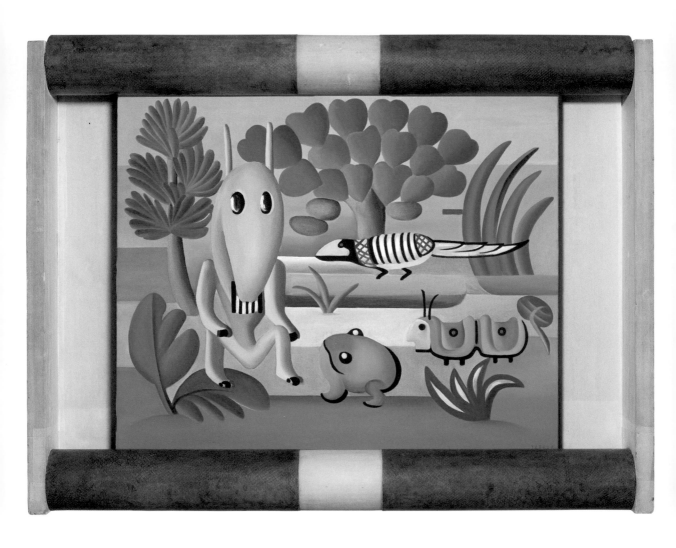

FIG. 25. Tarsila do Amaral (Brazilian, 1886–1973). *The Cuca*. 1924. Oil on canvas with frame by Pierre Legrain: 30 ½ × 39 ¼" (77.5 × 99.7 cm). MUSÉE DE GRENOBLE

FIG. 26. The Indaiatuba region of Brazil, photographed by Tarsila do Amaral, 1928

Amaral and Oswald traveled extensively after the exhibition before returning home in August 1926 and marrying that October. They stayed in Brazil for a year and a half, eventually going back to France a few months before Amaral's June 1928 exhibition at Galerie Percier. Mário called her return to Brazil the "five o'clock of her existence," a reference to teatime, as she and Oswald socialized with their friends and families and reconnected to ongoing debates about modern art and literature.[38] Her renewed interaction with her circle was matched by increasingly inventive paintings. Stylistically, she reduced and intensified her unique and joyful palette and further smoothed and stylized her subjects. She played with scale and juxtaposition, eliminating certain details and magnifying others to build emotional, enigmatic compositions rather than Cubist-constructed stacks. Beyond the radical reimagining of her style, she created scenes, as in *The Cuca*, of symbolic rather than descriptive references to Brazil—although their stripped-down horizon lines and otherworldly settings have been compared to the landscape of her childhood **[FIG. 26]**.[39] In *Manacá*, one of the few works she painted in 1927, a creamy white sky and two light-blue mounds represent a schematic background for a giant fantastic flower that emerges from a weave of tubular, cactus-like forms **[FIG. 27]**. The manacá blossom, its popular Brazilian name derived from the Tupi language, is sacred to Indigenous groups in recognition of the plant's medicinal and magical properties.

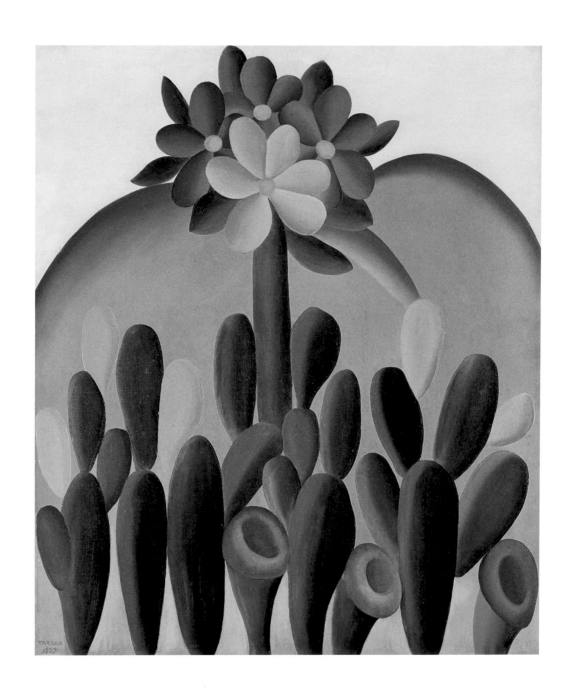

FIG. 27. Tarsila do Amaral (Brazilian, 1886–1973). *Manacá*. 1927. Oil on canvas, 29¹⁵⁄₁₆ × 25" (76 × 63.5 cm).
PRIVATE COLLECTION, SÃO PAULO

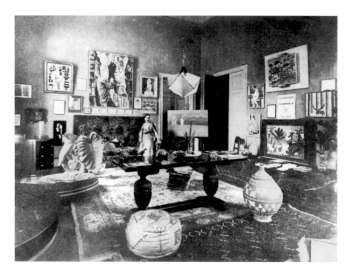

FIG. 28. Tarsila do Amaral in the salon of her São Paulo home, 1930

Amaral's new works were made in service to the drive to Brazilianize culture, as a 1927 poem jointly authored by Mário and Oswald (or "Marioswald") made clear:

> Tarsila paints no more
> With Paris green
> She paints with
> Cataguazes Green [40]

The collaborative poem was written in support of a regional modernist group from Cataguases, in Minas Gerais, and it was published in the group's magazine, *Verde*, named for the green of the Brazilian flag. In the playful, pun-filled work, the poets included themselves in a list of artists whose creations were made in "Cataguazes Green," whether ink, clay, sound, or paint, claiming for Brazil the very materials from which the works were made.

In February 1928 a reporter from the São Paulo newspaper *Diário da Noite* was invited to Amaral's home to see some of the twelve canvases that would go on view later that year in Paris [**FIG. 28**]. The journalist noted the significant change in her work: "Compared to her paintings of days past, Tarsila do Amaral's current works reveal a new stage in the development of her artistic nature. . . . Cubism's realist, objective period has passed; it is over. D. Tarsila do Amaral has also moved on to subjectivism." Referring, perhaps, to *Abaporu*, he made special mention of "a mysterious canvas, redolent of *macumba*." [41]

There is no mention of *The Moon* or Anthropophagy in the article; Oswald's manifesto had yet to be published. But he was present during the interview, and the evocation of "macumba"—a term for Afro-Brazilian religions—hints at the

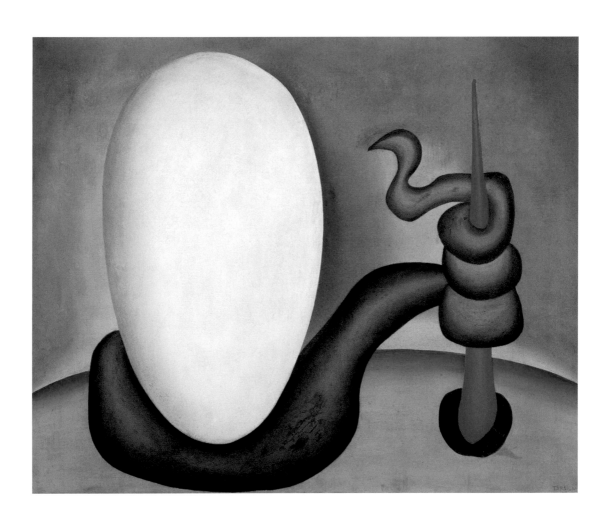

FIG. 29. Tarsila do Amaral (Brazilian, 1886–1973). *Urutu Viper.* 1928. Oil on canvas, 23 ⅝ × 28 ⅜" (60 × 72 cm). MUSEU DE ARTE MODERNA, RIO DE JANEIRO. COLEÇÃO GILBERTO CHATEAUBRIAND

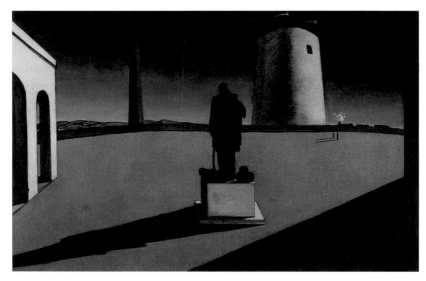

FIG. 30. Giorgio de Chirico (Italian, 1888–1978). *The Enigma of a Day*. 1914. Oil on canvas, 32 ¹¹/₁₆ × 51 ³/₁₆" (83 × 130 cm). MUSEU DE ARTE CONTEMPORÂNEA DA UNIVERSIDADE DE SÃO PAULO

conversation they might have had around Brazilianizing art and literature. Like *Abaporu*, her paintings continued to inspire or be in dialogue with those closest to the burgeoning Anthropophagic movement. It is hard to know which came first, for example: Amaral's painting *Urutu Viper*, featuring a poisonous Brazilian snake [**FIG. 29**]; Oswald's designation of Brazil as "the land of the big snake" in his Anthropophagic manifesto; or Bopp's dedication of his book *Cobra Norato* (written in 1928 and published in 1931) to Amaral.

The Moon, the largest and most complex of Amaral's paintings from this period, was made while key Anthropophagic texts were being written, but it can also be connected to the metaphysical works of the Italian painter Giorgio de Chirico. Amaral had met de Chirico in Paris and owned two of his paintings, including the 1914 work *The Enigma of a Day*—a deserted scene that is, like *The Moon*, equally divided into earth and sky by a gently curving horizon line [**FIG. 30**]. De Chirico's paintings were an early inspiration for the Surrealists, and Amaral's late-1920s landscapes speak to the ascendance of Surrealism in Paris at the time. Although not a follower of the movement, she certainly knew about it. Like her engagement with Cubism, which she harnessed for its iconoclasm, her nod to Surrealism acknowledged that movement's emancipatory potential, through its focus on the irrational and the unconscious—on feeling instead of reason. Oswald pursued the same kind of freedom in his Anthropophagic manifesto, privileging precolonial Brazilian happiness over European logic.

Indigenous Brazil was a popular subject in the literary works Amaral's friends were creating at this time, and many took a special interest in Indigenous

cosmology—including mythology around the moon. In *Macunaíma: A Hero without a Character*—part ethnography and part fantastical tale—Mário incorporated various celestial bodies from Brazilian myth.[42] The rhapsodic novel features Ci, Mother of the Forest, who was an Amazon and "one of that tribe of women living without any men on the shores of the lake called Mirror of the Moon."[43] She was the partner of Macunaíma, the titular "hero without a character," and when she died she became a star. The story recounts Macunaíma's adventures as he seeks to recover the amulet Ci gave him before her transformation. Along his journey he encounters Capei, the Moon Water Mamma, who tells him to go jump in the lake. Amaral may have known the work in draft form; Mário traveled through the Amazon in 1927 with a group that included her daughter, and an excerpt was published in *Verde* that November.[44] Featuring the moon paired with a river, *The Moon* may also have a direct link to Tupi lore, in which the moon goddess, Jaci, is the mother of all and creator of the Amazon.[45] Oswald mentioned the Tupi sun and moon gods in his Anthropophagic manifesto, humorously describing Guaraci, the sun, as "the mother of the living ones" and Jaci as "the mother of the vegetables."[46]

Even more significant in relation to *The Moon* is the Tupi poem Oswald quoted in his manifesto, which he took directly from a nineteenth-century work of anthropology titled *O selvagem* (The Wild), by José Vieira Couto de Magalhães:

Catiti Catiti	New moon, O new moon!
Imara Notiá	Blow memories of me on to . . . ;
Notiá Imara	here I am, I am in your presence;
Ipejú.	let me be only in your heart.[47]

This ode to the new moon conjures the same image we see in Amaral's painting, in which the heart-shaped cactus is positioned before the glowing golden crescent like an admirer. Evoked—or reflected—at the heart of Oswald's revolutionary manifesto, in the only passage written in a language native to Brazil, *The Moon* is not just a generic moonlit landscape: the light in the sky is a new Tupi moon, an Anthropophagic moon, a modern Brazilian moon. While Oswald asserted that happiness, Surrealist language, and the creation of time were uniquely Brazilian, Amaral made the same claim for the moon, recentering modernism on a cosmic scale in this portrait of her country.

———

Amaral returned to Brazil from Paris after her 1928 exhibition and had her first solo show there in July of the following year. Mounted at Rio de Janeiro's Palace Hotel, the exhibition did not include *The Moon*, but it did feature several Anthropophagic works, including the new painting *Anthropophagy* **[FIG. 31]**, which

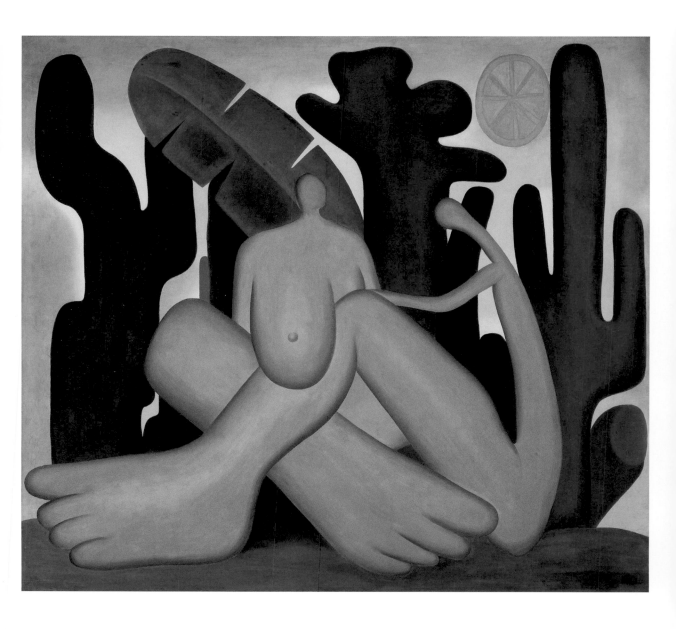

FIG. 31. Tarsila do Amaral (Brazilian, 1886–1973). *Anthropophagy.* 1929. Oil on canvas, 49 ⅝ × 55 ¹⁵⁄₁₆″ (126 × 142 cm). ACERVO DA FUNDAÇÃO JOSÉ E PAULINA NEMIROVSKY. ON LONG-TERM LOAN TO THE PINACOTECA DO ESTADO DE SÃO PAULO

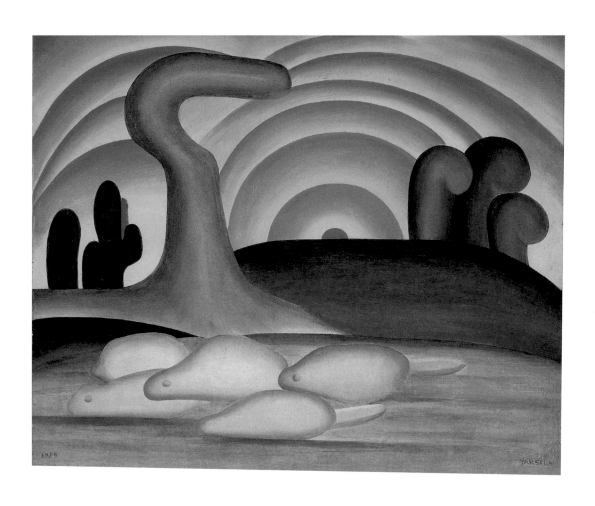

FIG. 32. Tarsila do Amaral (Brazilian, 1886–1973). *Setting Sun.* 1929. Oil on canvas, 21¼ × 25⁹⁄₁₆″ (54 × 65 cm).
PRIVATE COLLECTION, RIO DE JANEIRO

cannibalized the figures from her earlier paintings *The Negress* and *Abaporu*.[48] Also present was *Setting Sun*, with its brilliant semicircular bands of radiating orange and yellow [FIG. 32]. Thematically and stylistically similar to *The Moon*, it may have been conceived as its partner—a portrayal of Guaraci to pair with Jaci.

The exhibition was celebrated. Critics acknowledged Amaral's successes in Europe but especially emphasized her tremendous impact in Brazil. The São Paulo newspaper *Correio Paulistano* compared Amaral's artistic production to Brazil's declaration of independence: "Her painting is the most beautiful and audacious reaction that has ever been made, among us, against academicism, against the culture of importation, against any and all kinds of mental servitude, incompatible with a free America. It is our art's Cry of Ipiranga."[49] The show was hailed in the final issue of *Revista de Antropofagia* as "the first major battle for Anthropophagy."[50] But the world quickly shifted for Amaral. First she split with Oswald, who had taken up with a young writer. Then, in October 1929, the New York Stock Exchange crashed, lowering the price of coffee. She had to sell much of her collection of European modern painting to support herself, she mortgaged the farm, and she took a job at the Pinacoteca museum in the state of São Paulo, where she worked until she was forced out in the aftermath of the military coup of 1930. *The Moon* was not exhibited in Brazil until 1933, when it was hung in a retrospective exhibition organized to sell her works.[51] Given the challenging political climate, the artist had by then moved away from Anthropophagy to focus instead on the social and class-related inequalities of her country [FIG. 33].

Although Amaral was completely conversant in the trends of the Parisian art world, she was fully committed to Brazil. While her early works corresponded to the primitivist strategies and expectations of Paris, by the late 1920s, when she made *The Moon*, she had developed her own fluid and original language, creating a critical distance from the art world center and the literal scenes of her homeland that were often misread abroad. European viewers and critics did not always know how to decipher the codes in her Anthropophagic landscapes or her exuberant, almost cartoonlike style, but it did not matter. *The Moon* was a new kind of Brazilian art, driven by her generation's push for a reimagination of national culture. Hallucinatory and restless, the work may evoke a cosmic origin story, a Tupi goddess, or the artist's childhood night sky, but it is, above all, evidence of the remarkable trail Amaral blazed as she crafted her own voice and, through it, revolutionized modern art in Brazil.

FIG. 33. Tarsila do Amaral (Brazilian, 1886–1973). *Workers.* 1933. Oil on canvas, 59 ⅟₁₆″ × 6′ 8 ¹¹⁄₁₆″ (150 × 205 cm). ACERVO ARTÍSTICO-CULTURAL DOS PALÁCIOS DO GOVERNO DO ESTADO DE SÃO PAULO

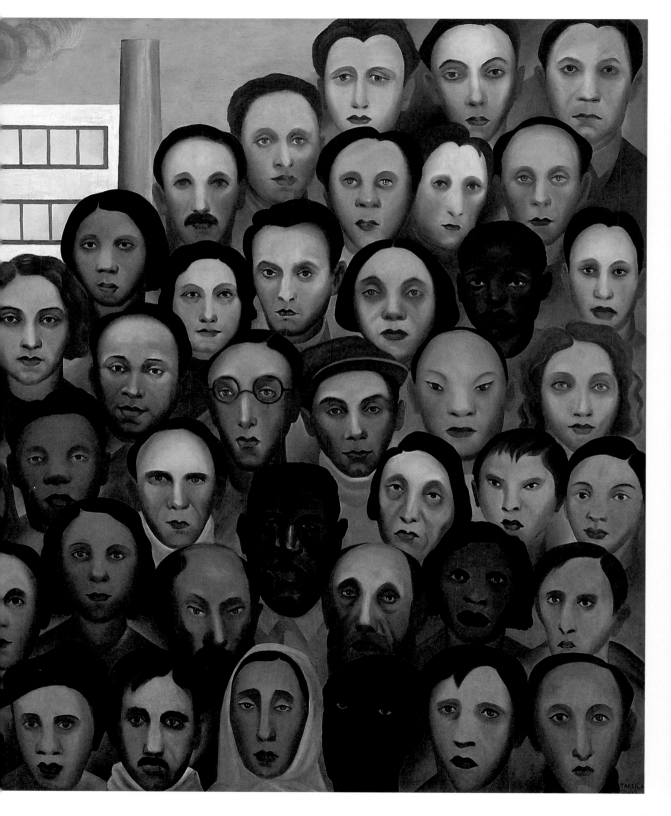

NOTES

1. Michele Greet makes these observations in "Devouring Surrealism: Tarsila do Amaral's *Abaporu*," *Papers of Surrealism*, no. 11 (Spring 2015): 11–12, 20.

2. Mário de Andrade, *Macunaíma* (1928), trans. E. A. Goodland (New York: Random House, 1984), 12–13.

3. Tarsila do Amaral, interview by Leo Gilson Ribeiro (1972), trans. Stephen Berg, in Stephanie D'Alessandro and Luis Pérez-Oramas, *Tarsila do Amaral: Inventing Modern Art in Brazil*, exh. cat. (Chicago: Art Institute of Chicago; New York: The Museum of Modern Art, 2018), 163.

4. Amaral, interview by Ribeiro, 163.

5. Oswald de Andrade, "Manifesto of Anthropophagy" (1928), trans. Hélio Oiticica, in D'Alessandro and Pérez-Oramas, *Inventing Modern Art in Brazil*, 177.

6. Andrade, "Manifesto of Anthropophagy," 176.

7. Pedro Fernandes Sardinha, the first bishop of Brazil, was captured and eaten by the Caeté people in 1556. Oswald concluded his manifesto with the date of its publication: "Year 374 of the Deglution [swallowing] of bishop Sardinha." Andrade, "Manifesto of Anthropophagy," 177.

8. Carlos Jáuregui, "Anthropophagy," in *Dictionary of Latin American Cultural Studies*, ed. Robert McKee Irwin and Mónica Szurmuk (Gainesville, FL: University Press of Florida, 2012), 22.

9. Andrade, "Manifesto of Anthropophagy," 176, 177.

10. In São Paulo Amaral first worked in the studio of William Zadig, a Swedish sculptor, and with the Italian-Brazilian sculptor Oreste Mantovani. See "Chronology," in D'Alessandro and Pérez-Oramas, *Inventing Modern Art in Brazil*, 125.

11. Tarsila do Amaral to Anita Malfatti, October 26, 1920, quoted and trans. in Gillian Sneed, "Anita Malfatti and Tarsila do Amaral: Gender, Brasilidade and the Modernist Landscape," *Women's Art Journal* 34, no. 1 (Spring/Summer 2013): 33. Amaral met Malfatti in Pedro Alexandrino's studio (32).

12. "Chronology," in D'Alessandro and Pérez-Oramas, *Inventing Modern Art in Brazil*, 125.

13. Tarsila do Amaral, "Full Confession" (1950), trans. Stephen Berg, in D'Alessandro and Pérez-Oramas, *Inventing Modern Art in Brazil*, 169.

14. Amaral, "Full Confession," 170.

15. Tarsila do Amaral, "Recollections of Paris" (1952), trans. Stephen Berg, in D'Alessandro and Pérez-Oramas, *Inventing Modern Art in Brazil*, 171.

16. Amaral, "Full Confession," 170.

17. Amaral, "Full Confession," 170.

18. "Modern Painting as Seen by an Extremely Modern Artist: Tarsila do Amaral Speaks to *O Jornal* on Her Way through Rio" (1926), trans. Stephen Berg, in D'Alessandro and Pérez-Oramas, *Inventing Modern Art in Brazil*, 157.

19. Marshall C. Eakin, *Becoming Brazilians: Race and National Identity in Twentieth-Century Brazil* (Cambridge, UK: Cambridge University Press, 2017), 16.

20. Paulo Herkenhoff, "The Two and the Only Tarsila," in *Tarsila do Amaral: Cannibalizing Modernism*, ed. Adriano Pedrosa and Fernando Oliva, exh. cat. (São Paulo: Museu de Arte de São Paulo Assis Chateaubriand, 2019), 106.

21. Tarsila do Amaral to her parents, April 19, 1923, quoted and trans. in Pedrosa and Oliva, *Cannibalizing Modernism*, 33.

22. Oswald de Andrade, "Atelier," in *Pau-Brasil* (Paris: Au Sans Pareil, 1925), 75–76. Trans. by the author. Paul Poiret (1879–1944) was a French fashion designer credited with establishing modern fashion in Paris in the early twentieth century.

23. Maria Castro, "Caipirinha," in Pedrosa and Oliva, *Cannibalizing Modernism*, 186.

24. When the painting was first exhibited, in the artist's 1926 exhibition at Galerie Percier, its title was given as *Négresse*. This has sometimes been translated to English using the more neutral descriptor *The Black Woman*, but I have chosen *The Negress* to more accurately reflect the meaning of the title in its original French context. The Portuguese translation is *A negra*.

25. Adriano Pedrosa, "A negra," in Pedrosa and Oliva, *Cannibalizing Modernism*, 188.

26. Rafael Cardoso, "White Skins, Black Masks: 'Antropofagia' and the Reversal of Primitivism," in *Das verirrte Kunstwerk: Bedeutung, Funktion und Manipulation von "Bilderfahrzeugen" in der Diaspora*, ed. Uwe Fleckner and Elena Tolstichin (Berlin: De Gruyter, 2020), 138–39.

27. Amaral and Brâncuși were friends, and she owned examples of his sculpture. It is likely that she saw *White Negress* in Brâncuși's Paris studio in July 1923. Cardoso, "White Skins, Black Masks," 134.

28. Cardoso, "White Skins, Black Masks," 136.

29. Mário de Andrade to Tarsila do Amaral, November 15, 1923, trans. Graham Howells, in D'Alessandro and Pérez-Oramas, *Inventing Modern Art in Brazil*, 166. In this source, the letter is erroneously dated to 1924.

30. "The Current State of the Arts in Europe: The Fascinating Brazilian Artist Tarsila do Amaral Gives Us Her Impressions" (1923), trans. Stephen Berg, in D'Alessandro and Pérez-Oramas, *Inventing Modern Art in Brazil*, 156.

31. Oswald's poetry collection *Pau-Brasil* is dedicated "to Blaise Cendrars on the occasion of the discovery of Brazil."

32. Oswald de Andrade, "Pau-Brasil Poetry Manifesto" (1924), trans. Polyglossia, in Dawn Ades, *Art in Latin America: The Modern Era, 1820–1980* (New Haven, CT: Yale University Press, 1989), 311. The manifesto was published in the Rio de Janeiro newspaper *Correio da Manhã* on March 18, 1924.

33. Andrade, "Pau-Brasil Poetry Manifesto," 311.

34. Andrade, "Pau-Brasil Poetry Manifesto," 310.

35. Tarsila do Amaral, "Pau-Brasil and Anthropophagite Painting" (1939), in *Tarsila do Amaral*, ed. Aracy Amaral et al., exh. cat. (Madrid: Fundación Juan March, 2009), 31.

36. Memmi, "Une exposition des peintres étrangers," *L'humanité*, June 28, 1926, 4, quoted and trans. in Cardoso, "White Skins, Black Masks," 141.

37. "Tarsila," *Vogue* (Paris), September 1, 1926, 60, quoted and trans. in Cardoso, "White Skins, Black Masks," 142.

38. Mário de Andrade, "Tarsila," in *Tarsila: Rio–1929*, exh. cat. (Rio de de Janeiro: Palace Hotel, 1929), 21. Trans. by the author.

39. Aracy Amaral, "O Surreal em Tarsila," *Mirante das artes*, no. 3 (May/June 1967): 23.

40. Marioswald [Mário de Andrade and Oswald de Andrade], "Homenagem aos homens que agem," *Verde: Revista mensual de arte e cultura* 1, no. 4 (December 1927): 9. The first stanza of the poem is translated in Amaral et. al, *Tarsila do Amaral*, 83.

41. "Tarsila do Amaral Speaks of Her Art and Her Triumphs and Hopes: A Success That Reverberated throughout the World, Except for Blessed Brazil" (1928), trans. Stephen Berg, in D'Alessandro and Pérez-Oramas, *Inventing Modern Art in Brazil*, 158.

42. In his writing, Mário referred to the Indigenous legends collected by German ethnographer Theodor Koch-Grünberg in his five-volume travel account *Vom Roroima zum Orinoco: Ergebnisse einer Reise in Nordbrasilien und Venezuela in den Jahren 1911–1913* (Berlin: D. Reimer, 1916–28).

43. Andrade, *Macunaíma*, 16. Michele Greet makes the connection between Mário's "Mirror of the Moon" and Amaral's *The Moon* in "A lua," in Pedrosa and Oliva, *Cannibalizing Modernism*, 242.

44. Amaral and Oswald met the party in Salvador, Bahia, in August 1927, at the end of the three-month journey. The excerpt from *Macunaíma*, titled "Caso da cascata" (Waterfall Tale), was published in *Verde* 1, no. 3 (November 1927): 12.

45. Stephen Berg, "An Introduction to Oswald de Andrade's *Cannibalist Manifesto*," *Third Text* 13, no. 46 (1999): 90.

46. Andrade, "Manifesto of Anthropophagy," 177.

47. Oswald de Andrade, "The Cannibalist Manifesto," trans. Stephen Berg, *Third Text* 13, no. 46 (1999): 93.

48. The latter two works were not on view.

49. "Tarsila do Amaral vai fazer a sua primeira exposição no Rio," *Correio Paulistano*, July 18, 1929, 4. Trans. by the author.

50. "A exposição de Tarsila do Amaral, no Palace Hotel, no Rio de Janeiro, foi a primeria grande batalha da Antropofagia," *Revista de Antropofagia*, no. 15, *dentição* 2 (August 1, 1929): 10. Trans. by the author. The second phase of the journal was published in the newspaper *Diário de São Paulo*.

51. The exhibition included sixty-seven paintings and 106 drawings. Regina Teixeira de Barros, "Chronology," in Amaral et. al, *Tarsila do Amaral*, 248.

FOR FURTHER READING

Amaral, Aracy, Juan Manuel Bonet, Haroldo de Campos, and Jorge Schwartz. *Tarsila do Amaral*. Exh. cat. Madrid: Fundación Juan March, 2009. English edition.

Brownlee, Peter John, Valéria Piccoli, and Georgiana Uhlyarik, eds. *Picturing the Americas: Landscape Painting from Tierra del Fuego to the Arctic*. Exh. cat. Toronto: Art Gallery of Ontario; São Paulo: Pinacoteca do Estado de São Paulo; Chicago: Terra Foundation for American Art; in association with Yale University Press, 2015.

D'Alessandro, Stephanie, and Luis Pérez-Oramas. *Tarsila do Amaral: Inventing Modern Art in Brazil*. Exh. cat. Chicago: Art Institute of Chicago; New York: The Museum of Modern Art, 2018.

Greet, Michele. *Transatlantic Encounters: Latin American Artists in Paris between the Wars*. New Haven, CT: Yale University Press, 2018.

Pedrosa, Adriano, and Fernando Oliva, eds. *Tarsila do Amaral: Cannibalizing Modernism*. Exh. cat. São Paulo: Museu de Arte de São Paulo Assis Chateaubriand, 2019. English edition.

Leadership support for this publication is provided by the Kate W. Cassidy Foundation.

Produced by the Department of Publications,
The Museum of Modern Art, New York

Leadership support for this publication is provided by
the Kate W. Cassidy Foundation.

Hannah Kim, Business and Marketing Director
Don McMahon, Editorial Director
Marc Sapir, Production Director
Curtis R. Scott, Associate Publisher

Edited by Rebecca Roberts
Series designed by Miko McGinty and Rita Jules
Layout by Amanda Washburn
Production by Matthew Pimm
Proofread by Sophie Golub
Printed and bound by Ofset Yapımevi, Istanbul

Typeset in Ideal Sans
Printed on 150 gsm Arctic Silk Plus

Published by The Museum of Modern Art
11 West 53 Street
New York, NY 10019-5497
www.moma.org

ISBN: 978-1-63345-135-3

Distributed in the United States and Canada by
ARTBOOK | D.A.P.
75 Broad Street
Suite 630
New York, NY 10004
www.artbook.com

Distributed outside the United States and Canada by
Thames & Hudson
181A High Holborn
London WC1V 7QX
www.thamesandhudson.com

Printed and bound in Turkey